all these black days — between

REBECCA HORN

all these black days — between

Scalo Zurich – Berlin – New York

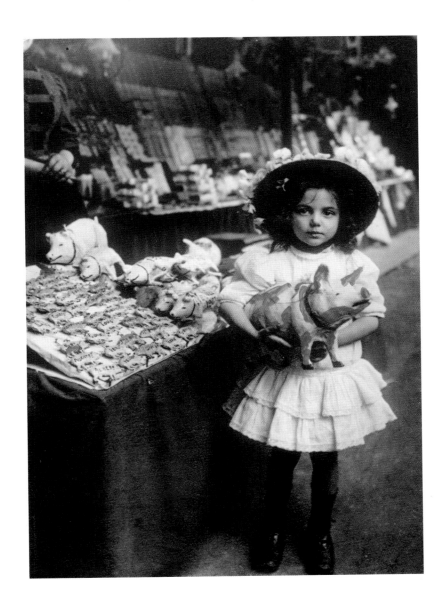

The moon, my head, the pumpkins "shrinkling"
Air of lemon juice around
Prepared to dance with pin-heads
Trying not to lose my skin
— visiting last night this East Berlin cabaret

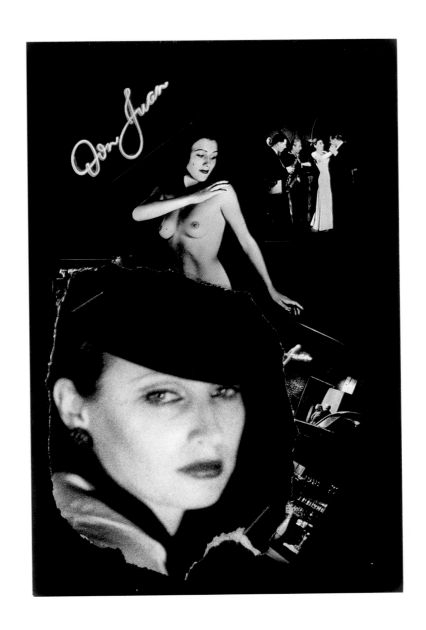

Sleeping on the back of a camel tonight

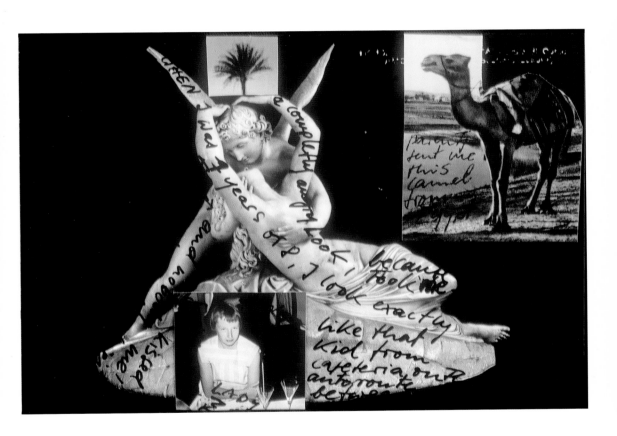

Rainy day, just passing through — Bonjour all over the place!
Out of our minds!
Hashes to hashes — dust to dust — Jesus saves Love!

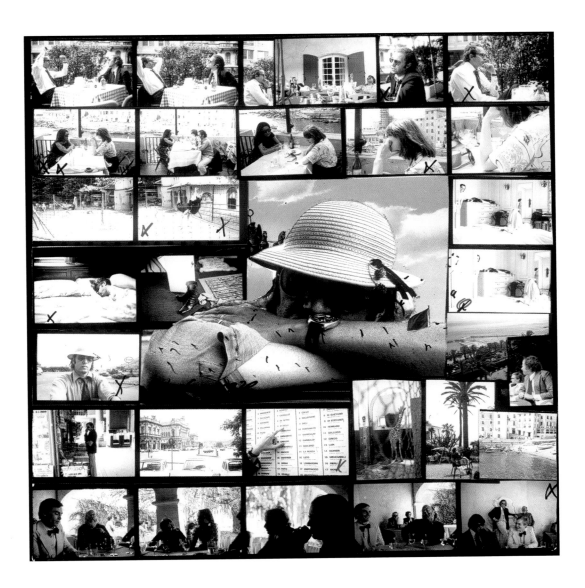

Thinking about a language for paradise
and needing a talk to you . . .
greetings from the rabbit's painting school.

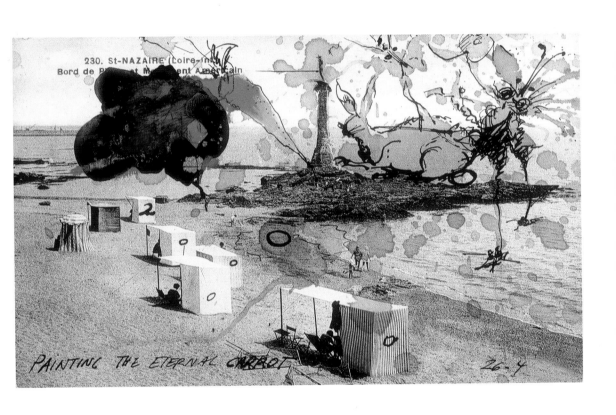

230. St-NAZAIRE (Loire-Inf)
Bord de Plage et Monument Américain

PAINTING THE ETERNAL CARROT

26·4

13

Thank God for calendars
that travel forward and not sideways.

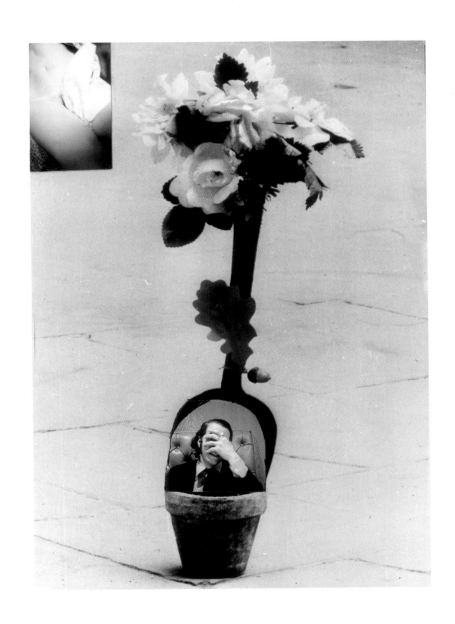

When I was four I perched up high
in a long silk dress in the branches of a walnut tree,
secretly observing the wedding guests.
They danced to the tunes of a violonist
in black tails. His tender melodies flowed
through my body and beyond the stars.
Trembling, I held onto the tree all night,
until the violonist rescued me from the branches,
carrying me barefoot away — across the dampened fields.
Now meeting him again in Barcelona, eighteen years thereafter,
where can I find you?

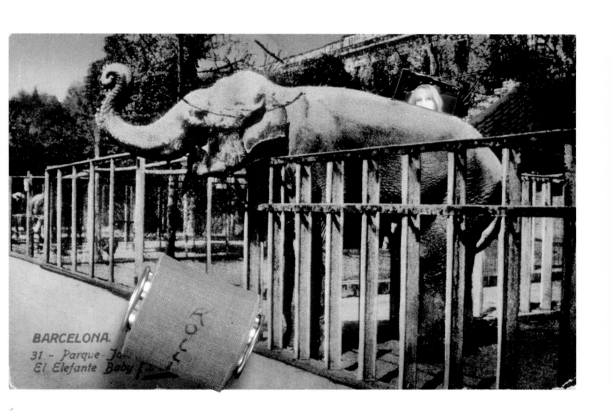

BARCELONA.
31 - Parque Jar...
El Elefante Baby...

Can you think about Buster Keaton being married
to the Mafia? Falling in love to such a creative mixture,
like sitting in a puddle of mud,
watching his hundred brides. . . .

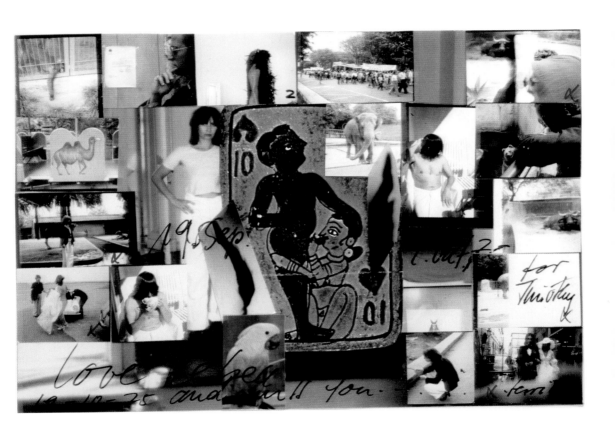

Love has made my head so remote from all
the other heads around me
I smile to my friends who show concern
promising them it is no rare tropical disease

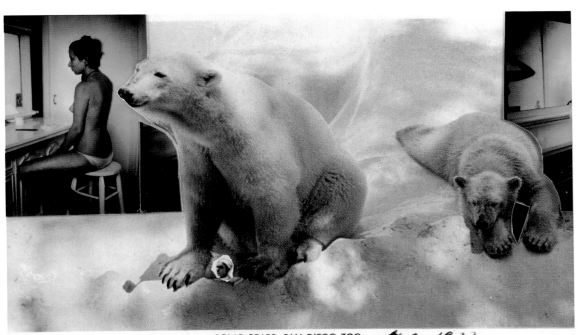

POLAR BEARS, SAN DIEGO ZOO, Aug 1977

In New York
2nd Avenue upside down reading Allen Ginsberg's
"Howl"

For two weeks back to my friends and animal heaven, twinkling with my Egyptian tango-hips over a star.

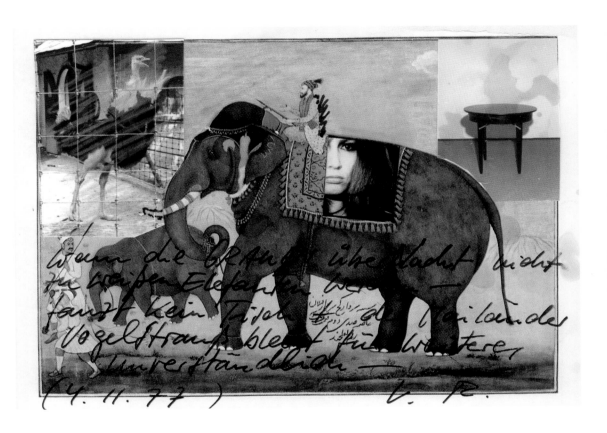

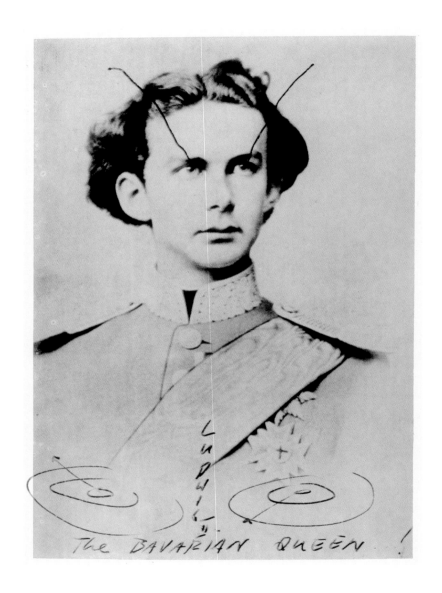

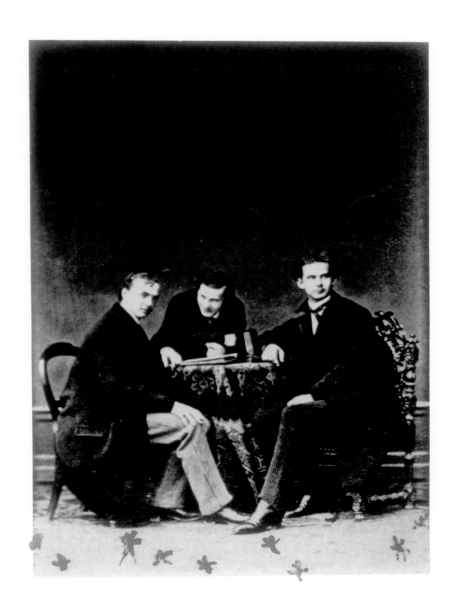

From Munich,
Ludwig and his friends waiting to be hunted . . .

Art = lonely camelstairs to heaven

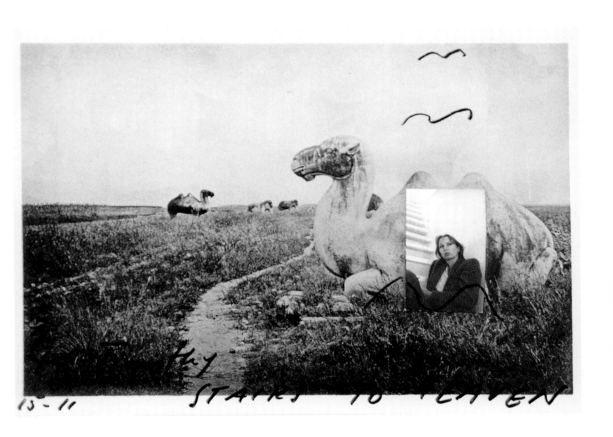

New York, shaving peaches.
And suddenly the black thin-legged table
starts dancing the tango
— even several times an hour.
Its agile movements descry the actuality
of its personality — that of an extraordinary gentleman,
in fact, the "Eintänzer."

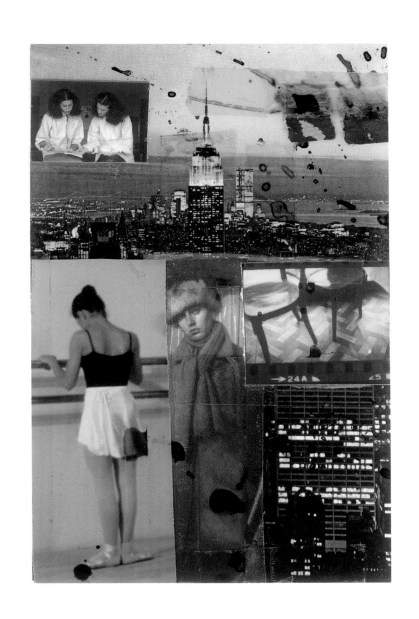

Wagnerian apparition:
ominous black omen

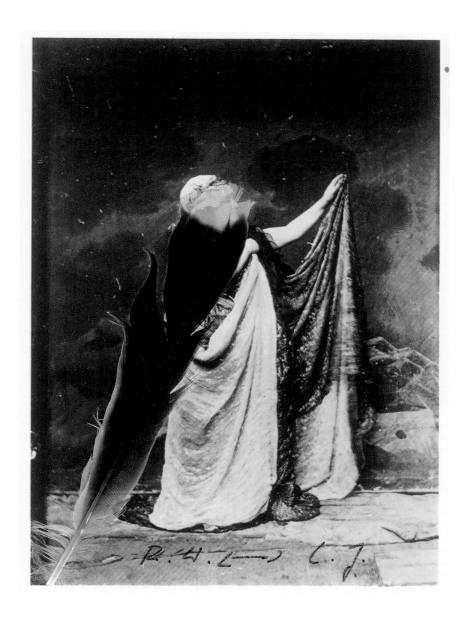

Whole afternoon playing shadow-tree,
hanging things over me, murmuring, moving as
shadows back and forth, till the sun disappeared entirely.
Finally reaching the top as the saddest monkey-tree
you have ever imagined.

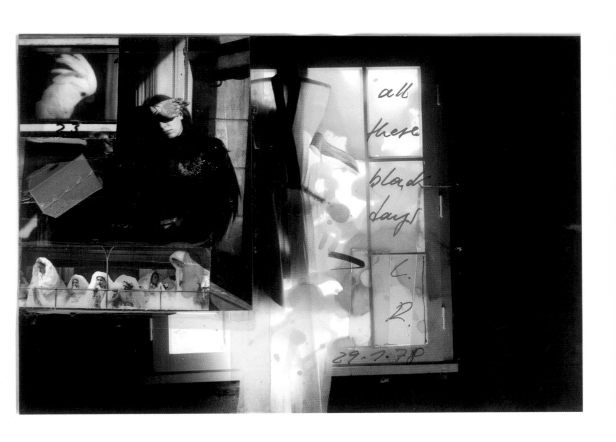

Screaming: you + me = having breakfast together once again.

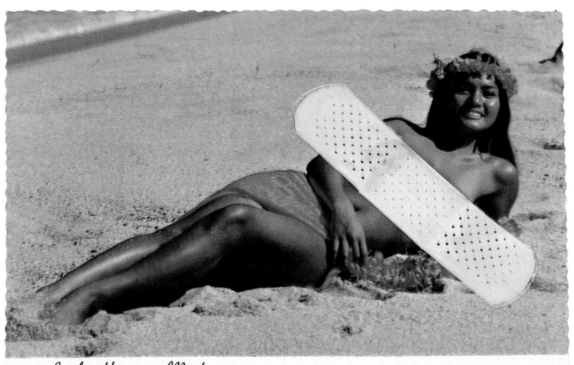

Lovely Hawaiian Maiden

On my way to Japan: boarding-school geisha!

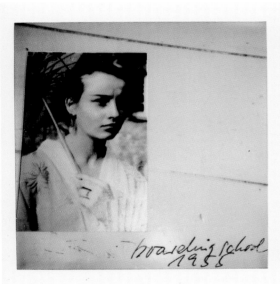

boarding school
1958

A PROPOS

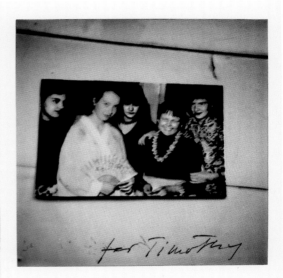

for Timothy

JAPAN

10.5.

Hong Kong,
dancing so far away, thinking of you,
Grande Hotel et des Palmes (Palermo)
and Raymond Roussel.

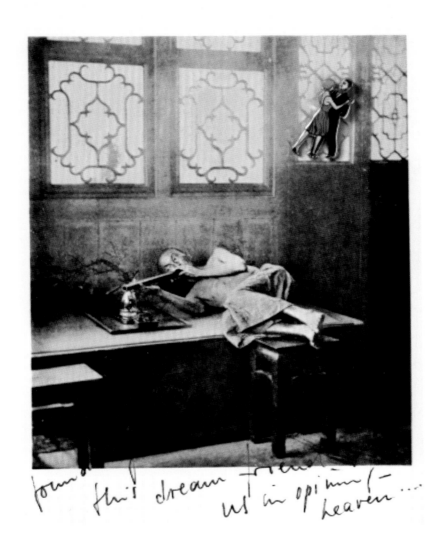

Playing "Misfits" rodeo in New Delhi,
with Montgomery Clift
conspicuously not present

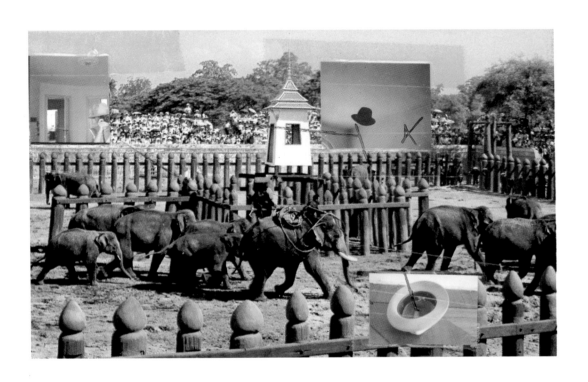

Italian intermezzo:
fox fur midnight risotto milanese

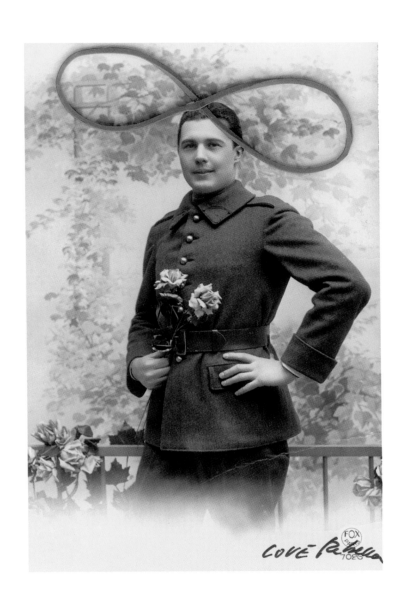

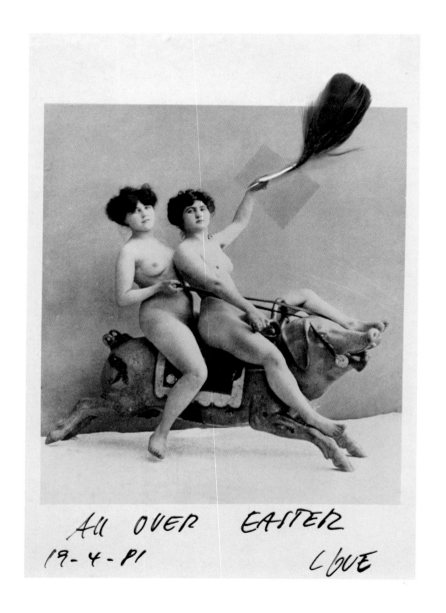

Feather-love dusters all over Europe...

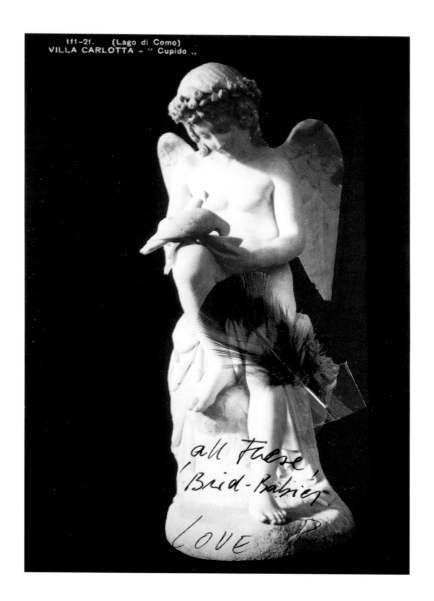

111-21. (Lago di Como)
VILLA CARLOTTA - " Cupido ,,

all These
'Bird-Babies'
LOVE

…also Ludwig Grand-dusting his friends too.

"La Tristeza" tango,
after returning from Buenos Aires

Sr. Majestät grösster Soldat „Der lange Josef" kompl. 2,39 m.

Greetings from Vienna,
Sigmund Freud was not allowed here, either…

Internationales Gesang- und Tanz-Trio.

DIE 3 PRINZESSINNEN AUS LILIPUT.
DIE 3 KLEINSTEN SCHWESTERN DER WELT.

Hartungsche Buchdruckerei, Königsberg i. Pr.

From Chicago, midnight
Elefant Kiss Blues
58 degrees below Fahrenheit outside
my peacock machine is frozen too.

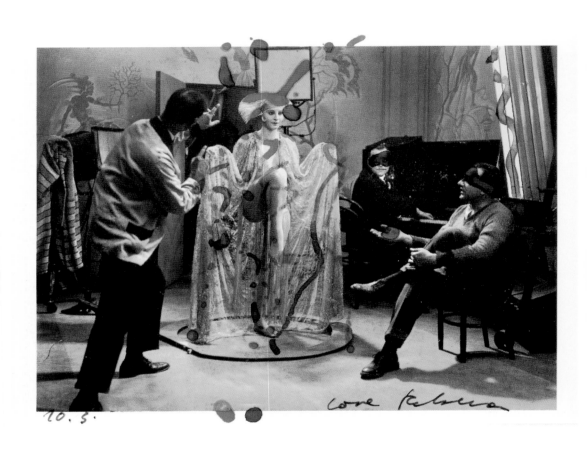

My arrival in L.A.

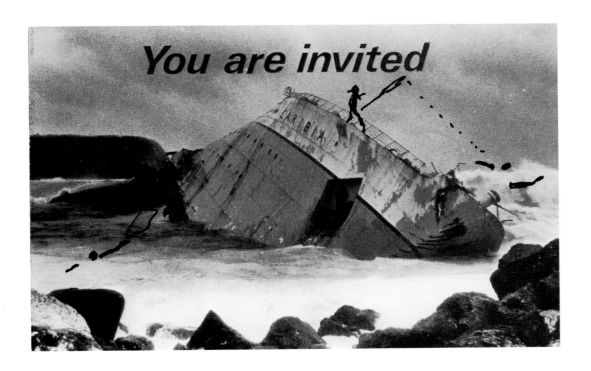

... to be a survivor

The "air-conditioned" Hollywood Kiss

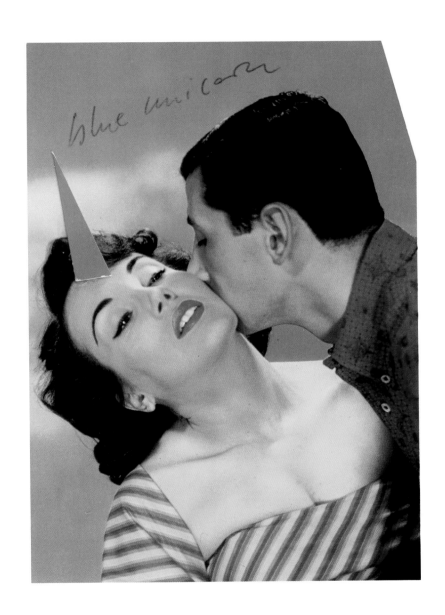

Luis Buñuel's New York dream lesson saves me:

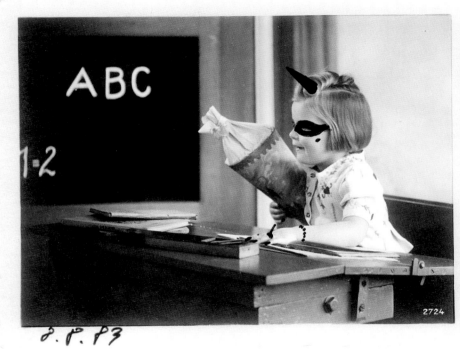

Cradling his bald, round head on my belly,
whispering which my favorite book could be,
I hestitate, thinking of so
many volumes right up until Proust,
and finally reply: I have none!
Then invent one yourself, he suggests:
from all of your personal tales and adventures.
He turns his head and giggling a little — nuzzles a moment
my red pubic hair
Then, suddenly sighing, disappearing through the screen of
my window, two days after dying in Mexico City.

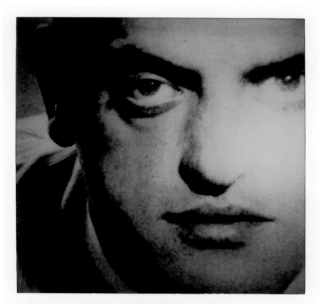

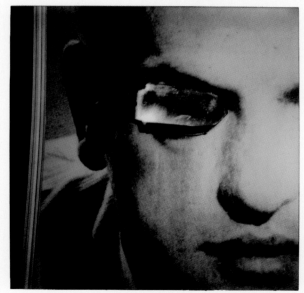

"La Ferdinanda,"
a Medici villa with one hundred chimneys
like whispering ears.
Alcoholic producer arrested, in jail,
Italian film crew all running away
and still, with the help of some wonderful friends,
creating this movie.

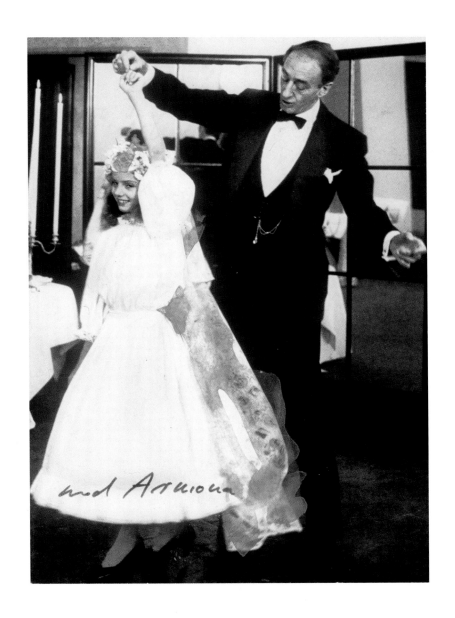

Back in Paris again...

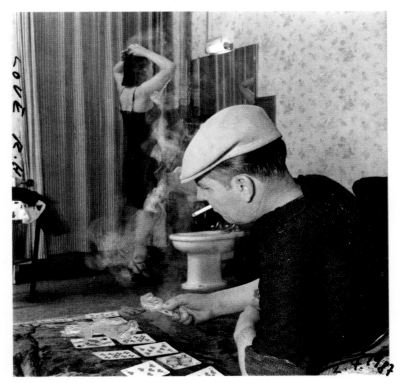

secret
PASSION
(photographed
Paris 1979/a spy!

Hotel Louisiana,
a seasick green room
and oysters all over the place.

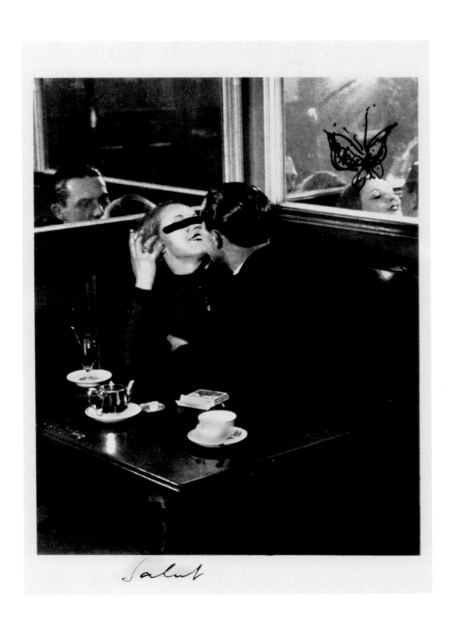

Salut

A visit to the Art Circus:
Tilly Bébé
the famous "dompteuse"
watched through champagne binoculars

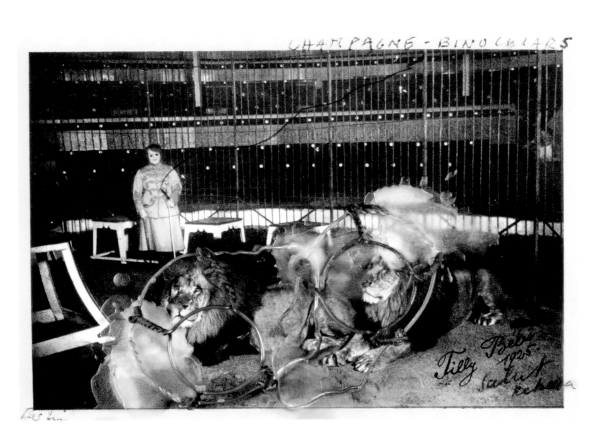

Oscar Wilde's Venetian inspiration ...

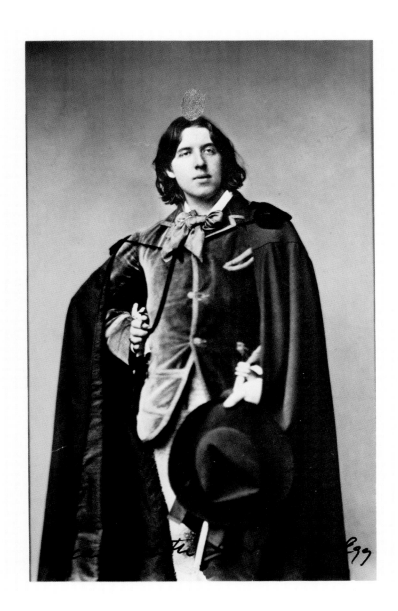

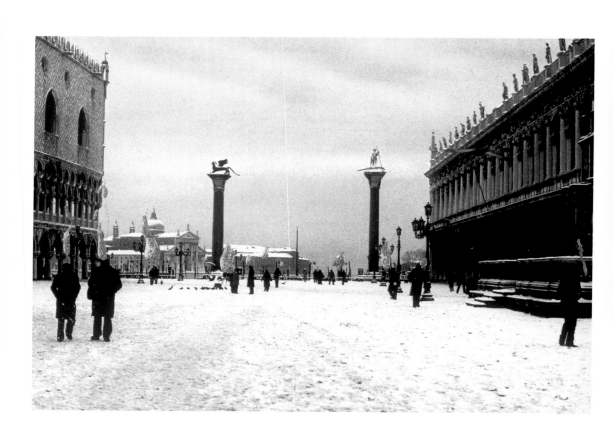

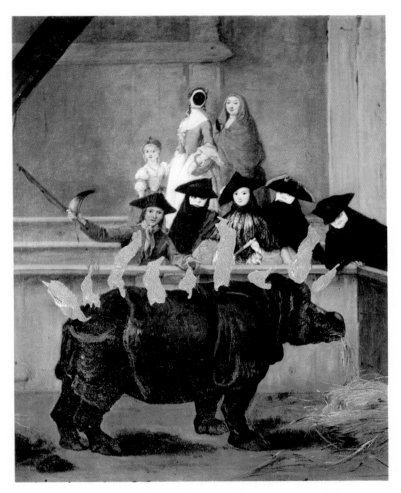

das Nilpferd – Nashorn fließt mit
LOVE Rahmen.

For you, in Berlin:
cooking up
pure golden happiness.

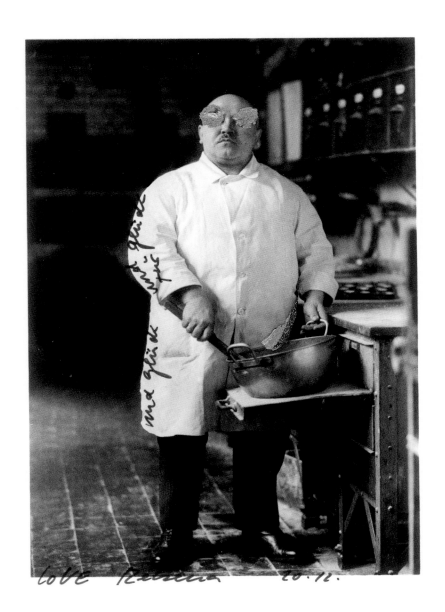

Back in New York,
the city choking on Ecstasy pills
spines liquidizing
106 degrees Fahrenheit
and me 37,000 feet up in the sky.

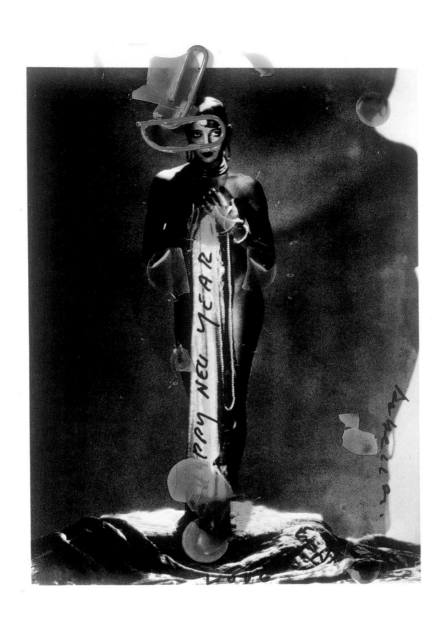

My uncle Harry and friends.
He moved with his butterfly collection
from New York to Chicago
where he started to bake little breads
became rich too quickly
and vanished under rather mysterious circumstances.

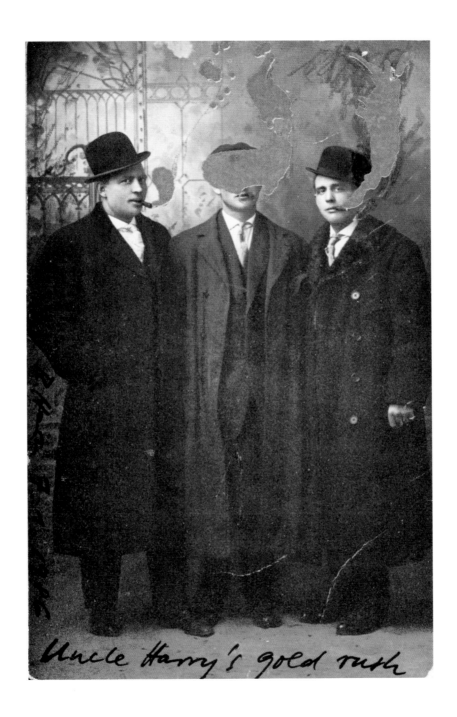

Uncle Harry's gold rush

Back again in L.A.,
can't compete with the Hollywood life
having the Butterfly Blues . . .

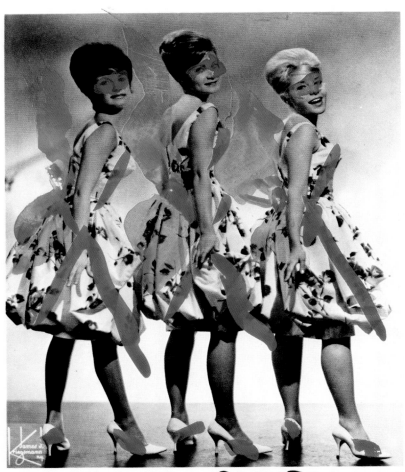

BLUE BLUES

New improvisations
rewriting the script
between blackest of walls
in my burnt-out New York studio

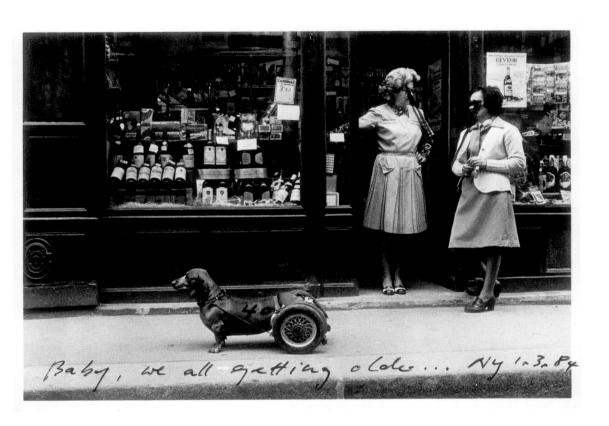

Baby, we all getting older... NY 1.3.84

Deer friend.

Surviving as Chinese tree.

Can't we meet in Paris next Thursday?

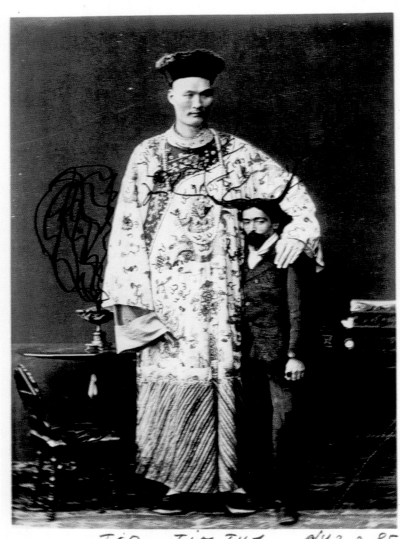

FOR TIMOTHY N.Y 2.2.85

… and suddenly, Buster Keaton appears again
disguised as George Washington
surveying the situation

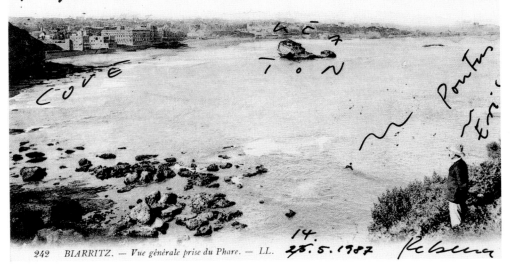

Plötzlich tauchte Buster Keaton als georg Washington getarnt in der Bucht auf.

242 BIARRITZ. — *Vue générale prise du Phare.* — LL.

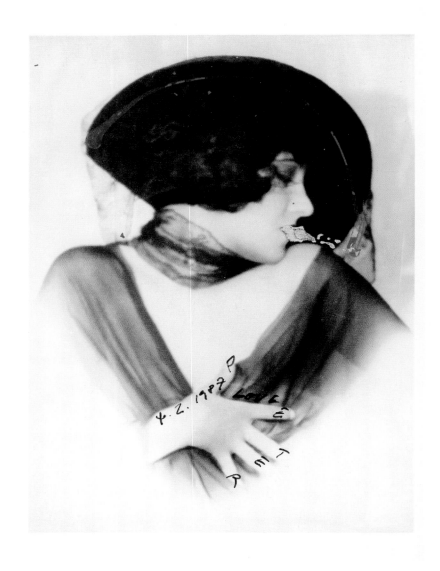

Stockholm legend

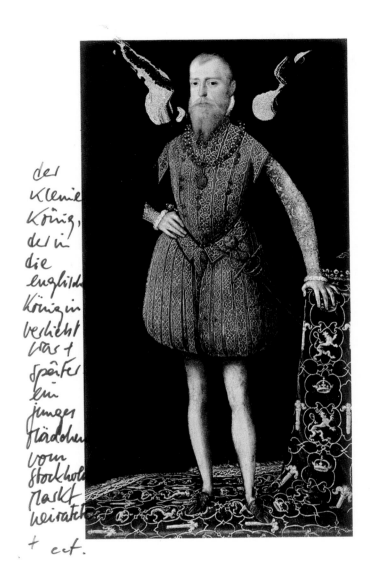

der kleine König, der in die englische Königin verliebt war + später ein junges Mädchen vom Stockholm Markt heiratet + ect.

Once more back in Paris,
Marina's tarot cards say....

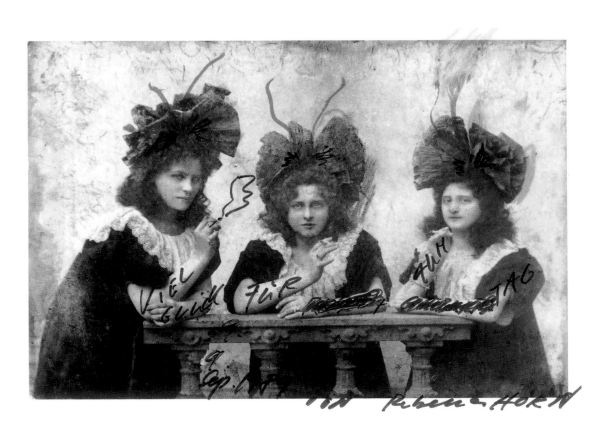

...that Hollywood is Switzerland
— charming a producer along the way

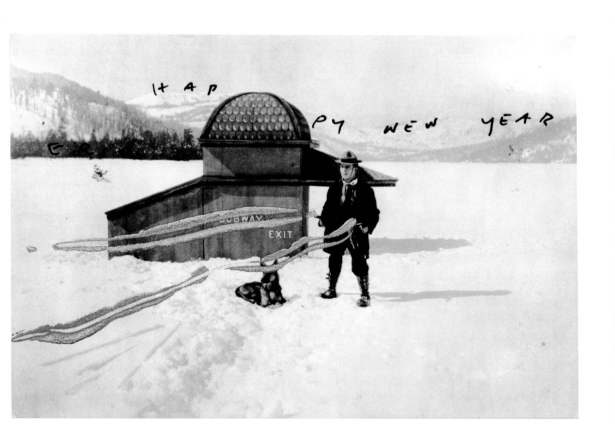

Narrowly escaping
an alpine Swiss crime

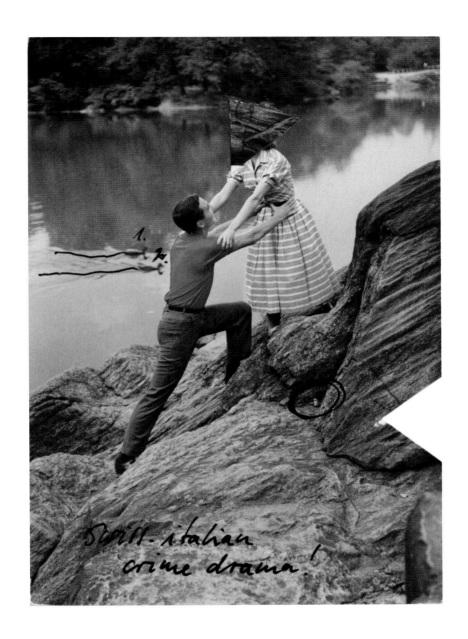

Fighting with little icepicks:
financing my movie.

mit den Eispickelchen ins neue Lebensjahr

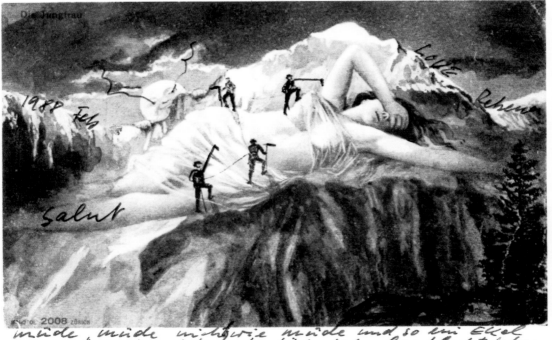

müde, müde unlustig wie müde und so ein Ekel
vor der Arbeit und dann das lächerliche Geschlechtsleben

Greetings from Paris,
after one night at Cirque d'Hiver,
new magic energies finally convince the producer...

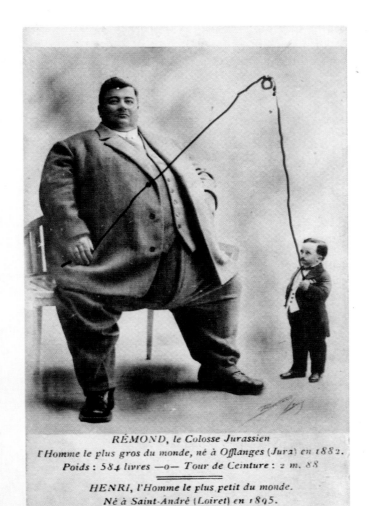

RÉMOND, le Colosse Jurassien
l'Homme le plus gros du monde, né à Offlanges (Jura) en 1882.
Poids : 584 livres —o— Tour de Ceinture : 2 m. 88

HENRI, l'Homme le plus petit du monde.
Né à Saint-André (Loiret) en 1895.
Taille : 70 centimètres —o— Poids : 14 kilos.

Shooting my film "Buster's Bedroom"
between Portugal and the Californian desert.
Don't lose me between the waves

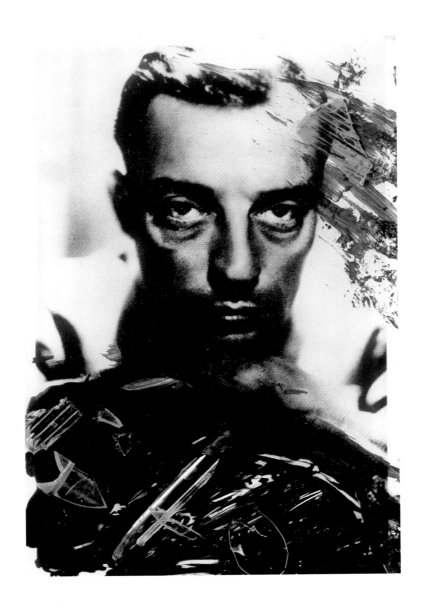

You have such beautiful reptilian eyes.
You never laugh;
why do you always seek danger?
Is it to have a reason to escape?
You are not afraid at all.
You don't need help.
You would run away from it anyway!
Keep to yourself.
There's nothing left to lose.
Take me to the other side of the ocean.
You can't get rid of me so easily.
—for you and Buster Keaton

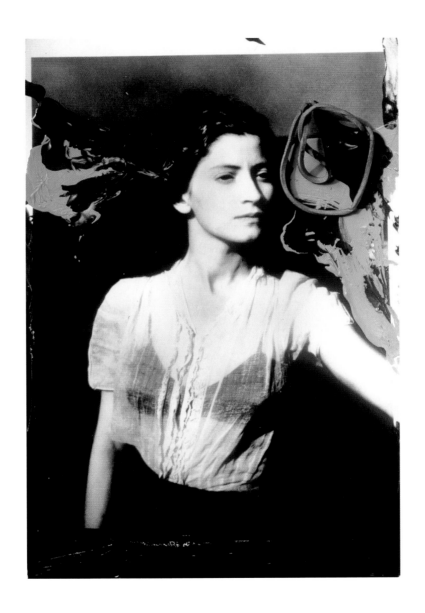

Trapped between rocks and huge black waves
a small trumpet should scatter the fog above:
phone call from the abyss

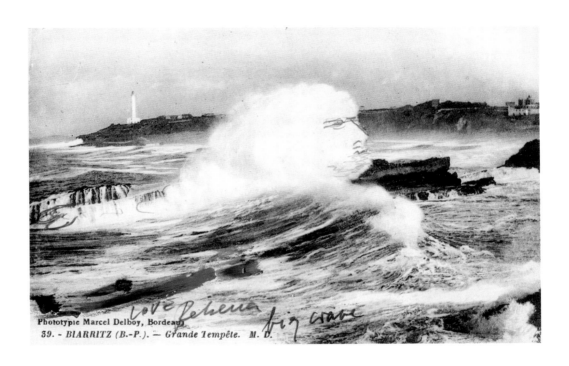

Phototypie Marcel Delboy, Bordeaux

39. - BIARRITZ (B.-P.). - Grande Tempête. M. D.

The final L. A. slow-motion separation

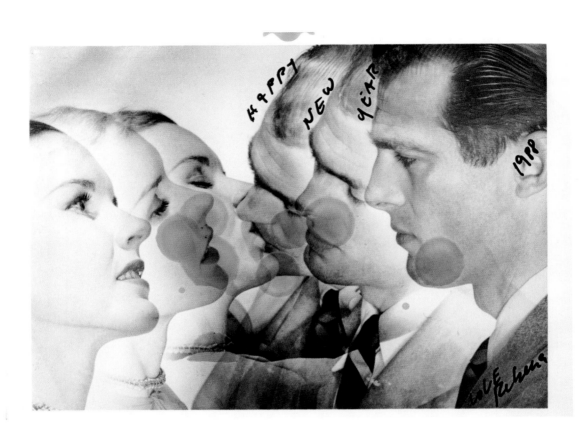

Berlin cocktail

3 bottles of Pomino

6 full moons

1 calcium-impregnated drop of blood

2 women's breasts

1 wounded sigh

1 pinch of tango

9 Japanese knives

… just to survive here.

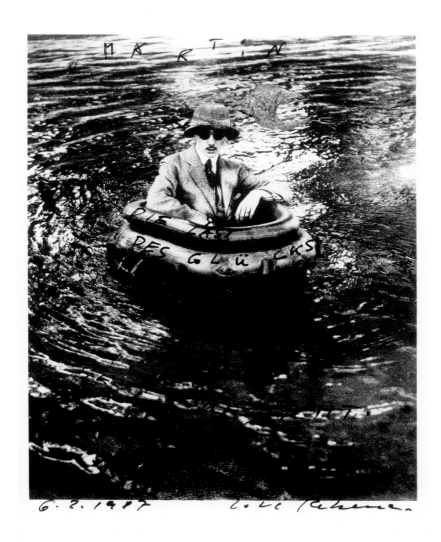

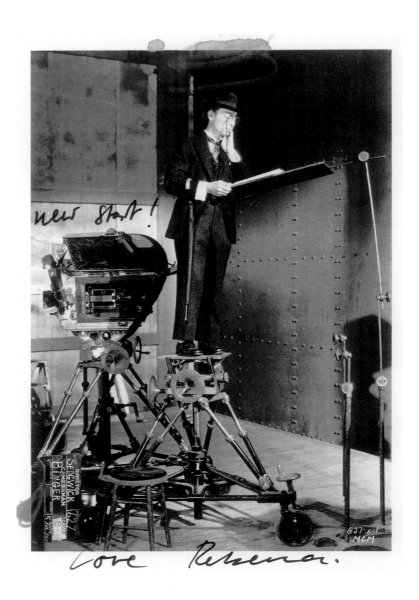

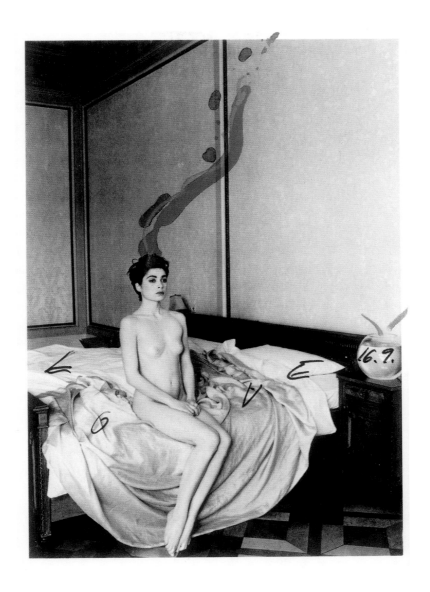

Still missing my shooting star

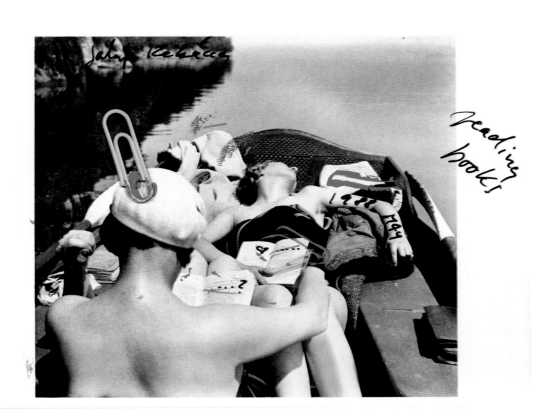

New musical game:
no numbers, no names

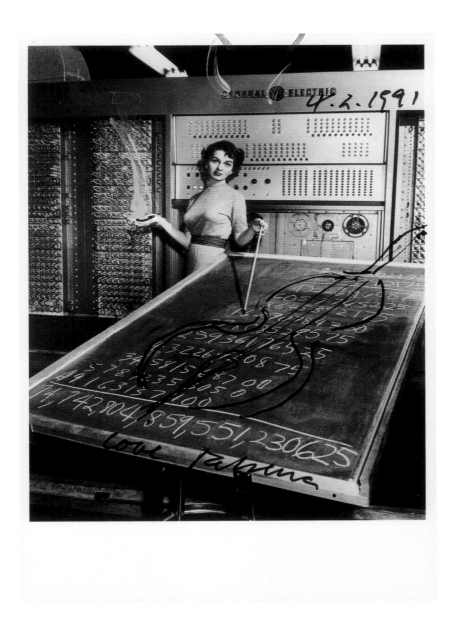

Barcelona song: Neige rouge.
It just never seems
to be the right cocktail hour
these days.

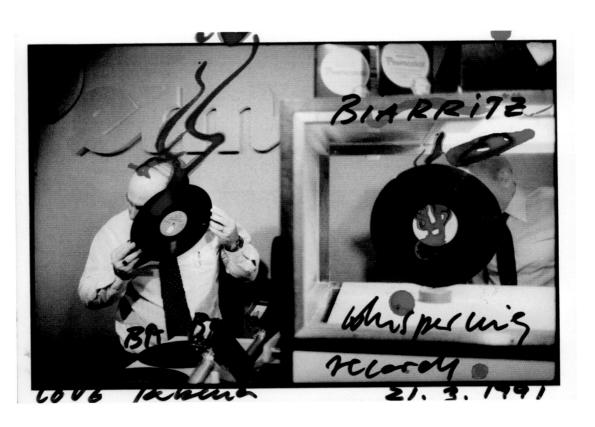

Back in Barrio Chino,
How can I sublimate emotions
before they explode in a flash of light?

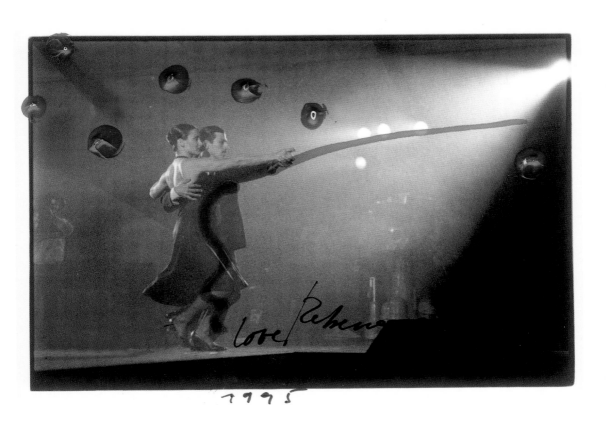

Sphinx and fox
wait deep within the pyramids
their hearts beating to opposite rhythms
waiting for the piano to drop from the ceiling
freeing them to fly and bathe at night
in the phosphorus of the sea.

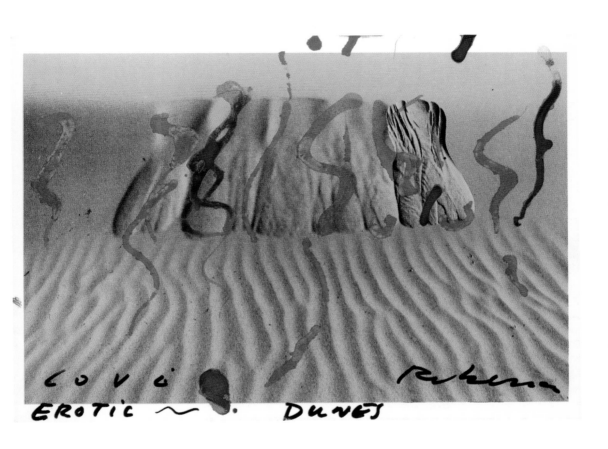

LOVE

EROTIC ～ ○. DUNES

From Marrakesh,
fata morgana on flying carpet

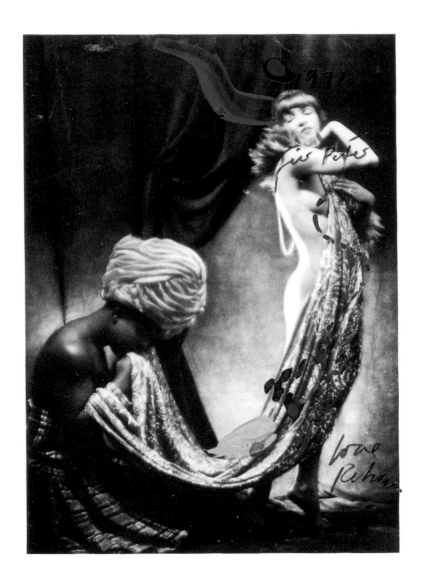

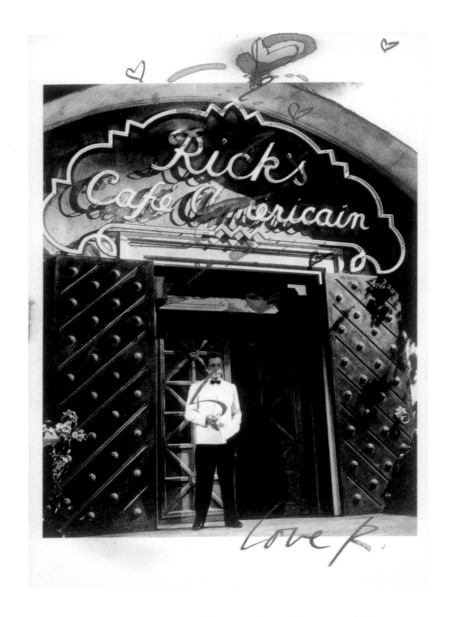

Come back to Casablanca if just for one night

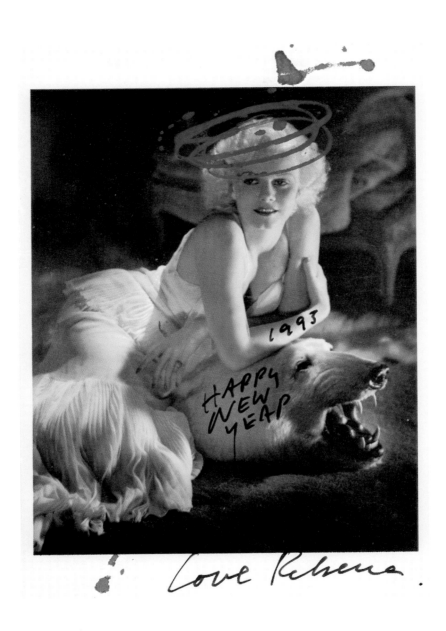

Life out of order
upside-down at best
penetration of endless rain
flashes of lightning shooting out of the wounded earth
no need for umbrellas or parachutes
why don't we leave for another planet ...

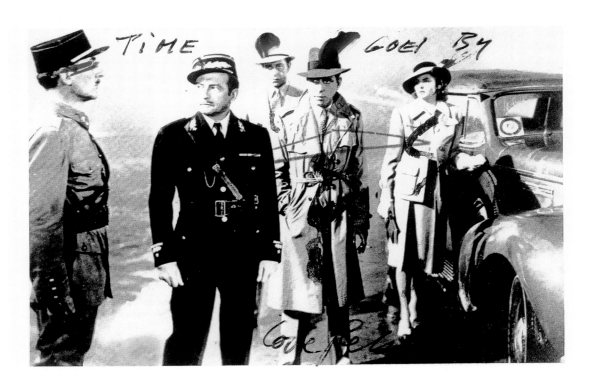

. . . where two oceans like us could meet in harmony?

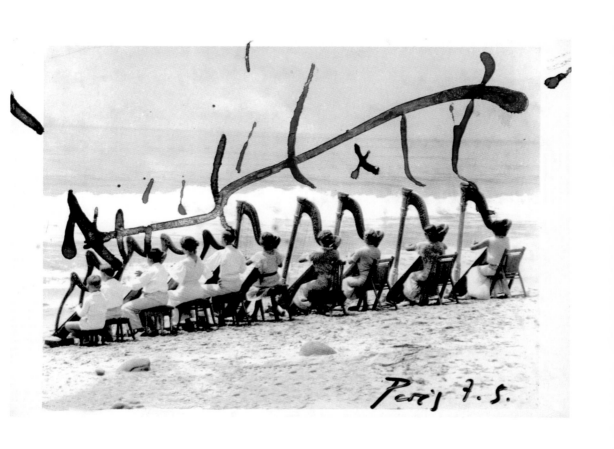

Ping-pong planet Havana,
he carries the rock as a pillow into the bed
resting on it like a lizard

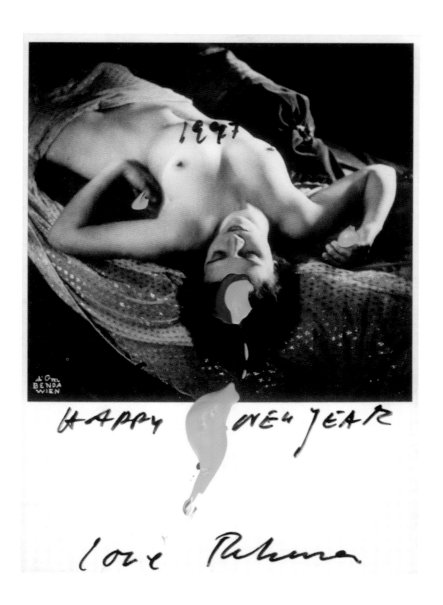

Full moon prescription:
get up for full moon
free yourself from the icebox
eat the lilies till you vaporise
howl like a wolf
allow black swans to skate on ice
drink the light of mercury
take off your clothes
grab your sex
and dance. . . .

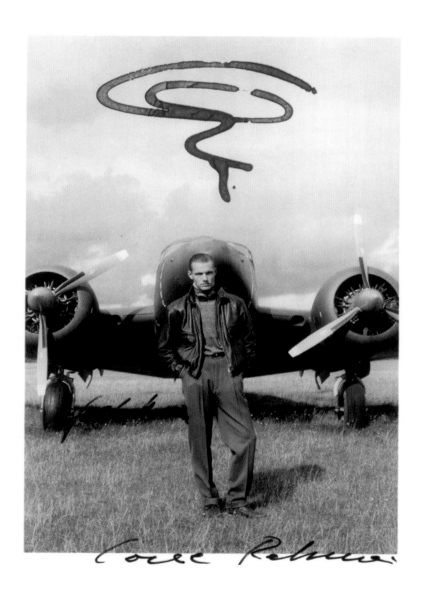

In Paris,
the moon casts shadows
absorbed by sleep
his touch is so hopelessly gentle
that it hurts.

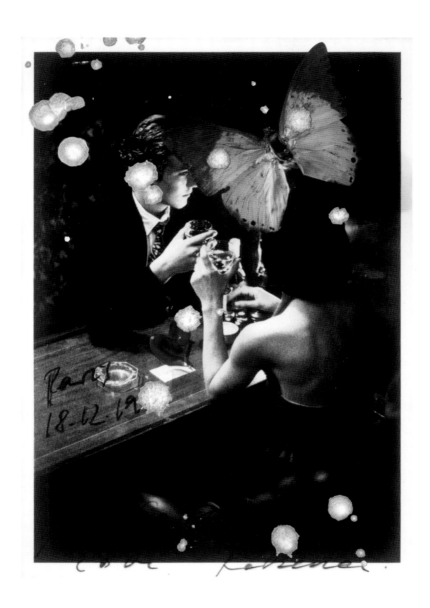

Later:
changing to flying dragon . . .

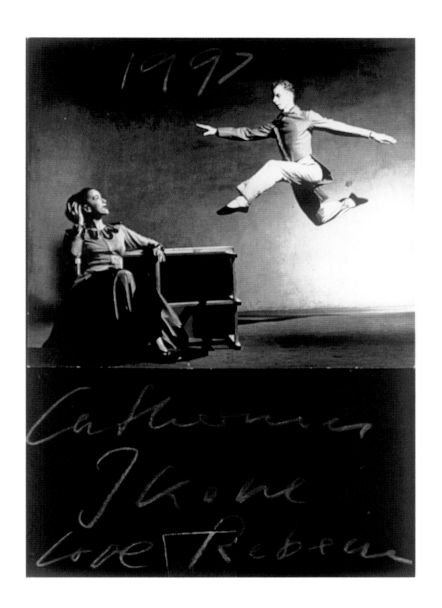

. . . hiding in secret hotel rooms,
under bed sheets and upside-down pianos . . .

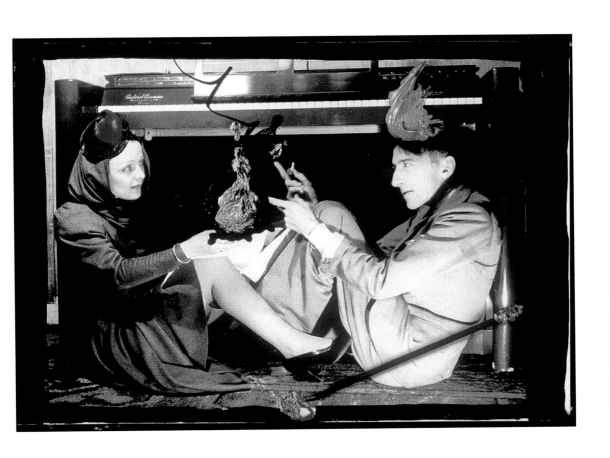

...till driven by pure love
he cut out the heart
in the shape of an obtuse triangle...

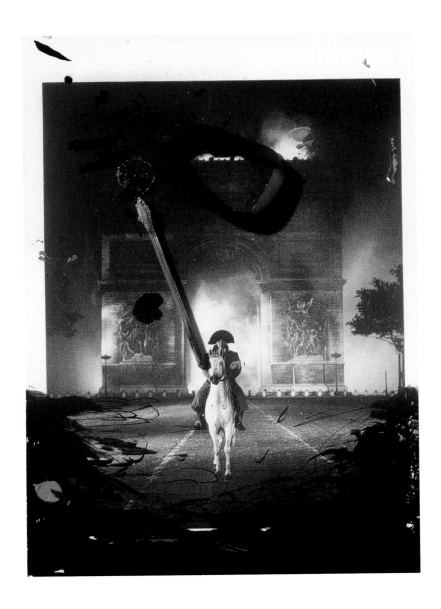

. . . because,
two soft stones grind each other down
to nothing

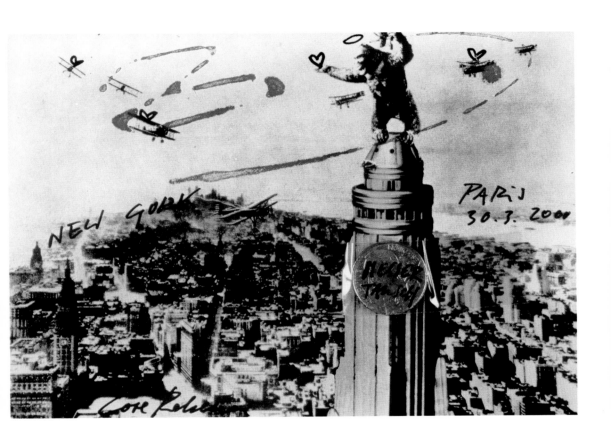

Back again to lonely copper moon...

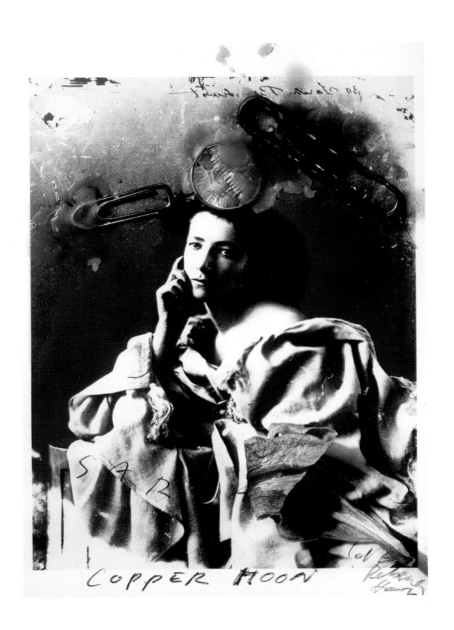

. . . till the magic wand becomes a rod of light
connecting above and below
with oscillating energy.

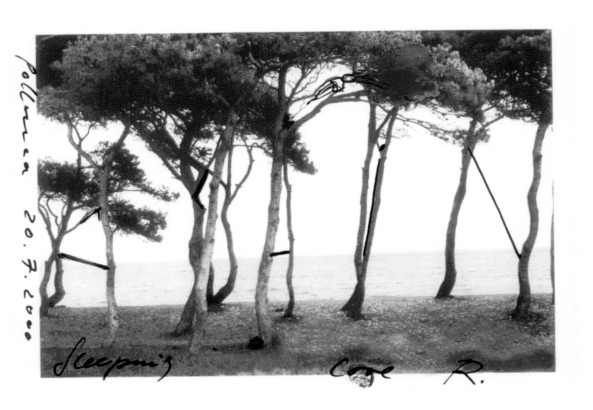

Lighting candles for everybody

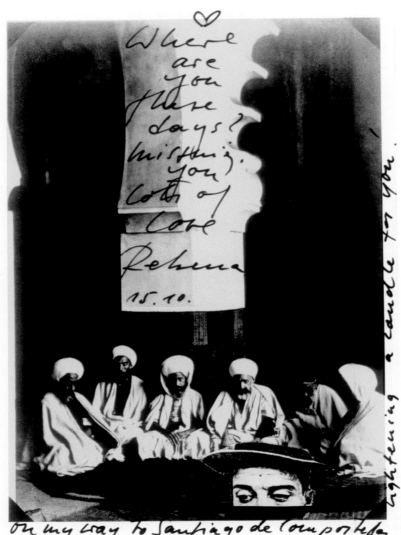

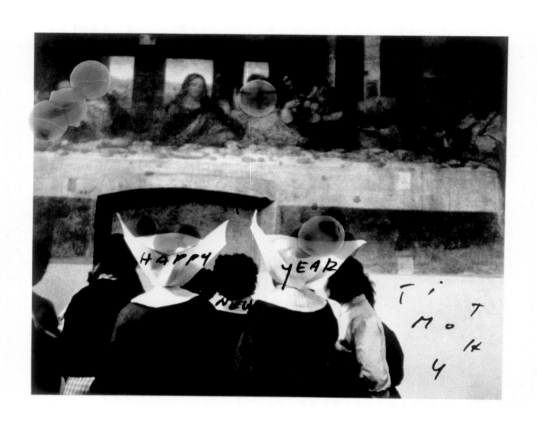

For Last Supper in last century

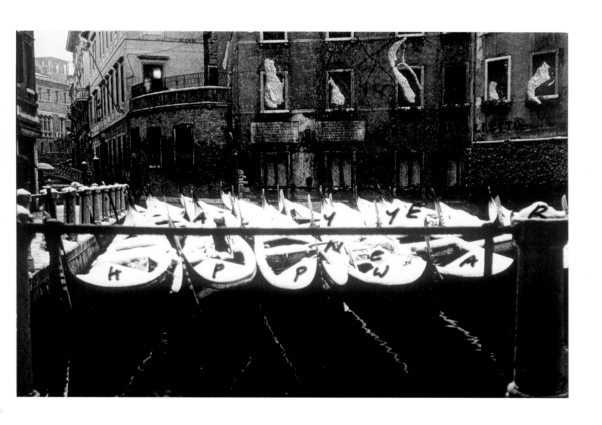

High up in the trees again
waiting to be reinspired.

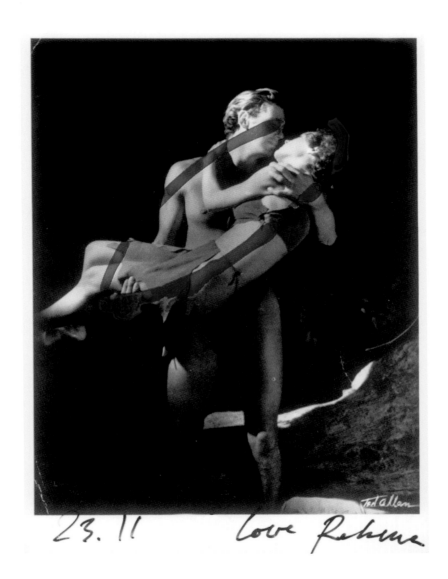

23. 11 love Rehana

Starting the Italian opera in Palermo:
Raymond Roussel's final night's vigil.

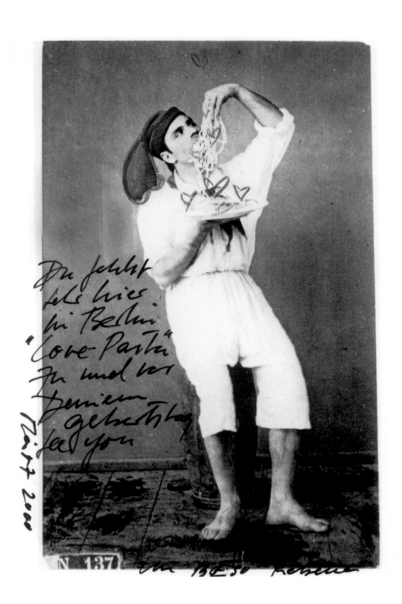

Postcard collages and texts
by Rebecca Horn,
sent to Timothy Baum
and friends

Rebecca Horn: All these black days — between

Design: Hans Werner Holzwarth, Berlin
Photographic Reproductions:
Heinz Hefele, Darmstadt, and Gunter Lepkowski, Berlin
Color separations: Satzpoint, Berlin
Printed by Primedia Th. Schäfer, Hanover

© 2001 for the original postcards: the producers and the authors
© 2001 for the texts and the appropriated postcards: Rebecca Horn
© 2001 for this edition: Scalo Zurich – Berlin – New York
Head office: Weinbergstrasse 22a, CH-8001 Zürich / Switzerland,
phone 41 1 261 0910, Fax 41 1 261 9262,
e-mail publishers@scalo.com, website www.scalo.com
Distributed in North America by D.A.P., New York City;
in Europe, Africa and Asia by Thames and Hudson, London;
in Germany, Austria and Switzerland by Scalo.

First Scalo Edition 2001
ISBN 3-908247-45-4
Printed in Germany